GW01375314

BORN TO BE WILD

HARLEYS, BIKERS & MUSIC FOR EASY RIDERS

Michael Stein ★ Michael Lichter

Coverphoto: Paul Cox, Sturgis Rally / South Dakota
© Michael Lichter Photography, LLC

First edition printed in 2006
Second edition printed in 2007
Third edition printed in 2010

© 2006 by edel CLASSICS GmbH, Hamburg / Germany
All photographs © Michael Lichter Photography, LLC; Michael Stein / Medieninformationsdienst (MI)
Please see index for individual photographic copyright
Please see tracklist credits for music copyrights

All rights whatsoever in this work and the photographs are strictly reserved.
No part of this book may be reproduced in any form without the prior consent from the publishers.

ISBN 978-3-937406-65-7

Editorial direction by Astrid Fischer / edel
Concept, texts and photo editorial by Michael Stein / MI
Music selection by Holger Müssener / HMH Music, Michael Stein / MI
Art direction and design by Sven Grot / Jens Bartoschek
Translation by ar.pege translations sprl

Produced by optimal media production GmbH, Röbel / Germany
Printed and manufactured in Germany

earBOOKS is a division of Edel Germany GmbH

For more information about earBOOKS please visit www.earbooks.net

OME RIDERS!

PREFACE

Reference books and practical guides to Harleys, custom bikes and the whole biker scene are legion. Books with artistic merit – and photos that show a strong emotional reaction to the topic – are much harder to find. The idea of combining such a photo gallery with a suitable CD music collection led to "Born To Be Wild". This earBOOK complements a wealth of images with a number of short articles on instructive and interesting subjects from the Harley scene.

The following pages display a cross section of the impressive photographic art of Michael Lichter, known above all for his many years of work for the American cult magazine Easyriders and the photographer of several specialist books. The pictures were all taken in the Harley-Davidson heartland. Enthusiasm for the legendary US motorcycle marque and the lifestyle that goes with it has long since ceased to be a purely American phenomenon. And so it seemed only appropriate to find space in this earBOOK for photos I have taken during my editorship, verging on a decade, of the European edition of Easyriders.

Even if the pictures in this book come from various continents, they all have one thing in common. They depict a scene that is not only wide-ranging geographically but is truly composed of widely differing strata. Harleys are no longer the preserve of enthusiastic aficionados. And the extravagant embellishments and super structures are no longer coveted solely by outlaws. Significantly, even many of the class differences have been lost where the high-capacity v-twins are concerned. The many regularly occurring events are just as likely to be attended by the archetypal dentist as by the mechanic or the female bank clerk. Whether they're dyed-in-the-wool rockers or Sunday rebels – they all feel, if only for a weekend at a time, that they are "Born To Be Wild"!

Michael Stein

Michael Stein
– Editor-in-Chief, Easyriders Europe –

MUSIC FOR EASY RIDERS

The sound ranges from solid blues and country sounds to Southern rock and metal sounds hard as bone – a sound that bikers will truly get wild about. The gap between music and motorcycles closes almost automatically: the bands rock, the bikes roll. And there's Rock'n'Roll for you! Or, in other words: music for easy riders.

Music and motorcycles have been inseparably linked ever since the movie "Easy Rider" (1969), if not before. Steppenwolf's "Born To Be Wild" from the film soundtrack became THE biker anthem of all times. And motorcyclists who wanted to be different from then on could only ride a Harley-Davidson – THE bike. Because Peter Fonda and Dennis Hopper did not just ride any machine in Easy Rider, but rebuilt Harley Panheads.

Although "Easy Rider" came to be the most popular biker film of all times by far, we shouldn't forget to mention "The Wild One". Despite the fact that he rode a Triumph, Marlon Brando played the boss of a motorcycle gang on the screen as early as in 1954. This movie not only fascinated the "yobbos", but influenced many musicians, too. And this isn't even a Rock 'n'Roll movie. But "The Wild One" did have the magic sounds of the engines! All that was missing, really, was the right kind of music. There's a long list of motor songs over the years: "Take The Highway" by The Marshall Tucker Band, Canned Heat's "On The Road Again", Molly Hatchet's "Kickstart To Fredoom", Saxon's "Motorcycle Man" or "Rockin' Down The Highway" by the Doobie Brothers, to name just a few examples.

Music for bikers doesn't always have to deal with riding a motorcycle. The tracks should, however, simply be done in an honest and handmade way. With a lot of feeling and a sound that, like the powerful v-twins, has the legendary good vibrations. Like the company from Milwaukee, the bands favoured by bikers don't always hanker for technical progress. In the end, neither the perfection of modern computer beats nor a technically perfect machine are needed. What counts are other things. "If I have to explain, you wouldn't understand!" is a widely used saying among riders of Harley machines. Perhaps nothing has to be explained once you've listened to the four CDs on this earBOOK...

MILWAUKEE IRON

In 1903, the first bike rolled from the wooden shed owned by Bill Harley and the brothers Arthur and Walter Davidson. The single cylinder machine still looked more like a bicycle with an engine, to be honest. But in 1909 it was followed by what was to become a myth over the years: the 45°-v-twin. Harley and the Davidson brothers always wanted to build reliable means of locomotion on two wheels. They managed to develop their shop into the world-famous motor company in next to no time. However, before the "Milwaukee iron" became the perfect cult object, there were some major setbacks to be overcome.

Even in 1920, the busy pioneers had managed to become global market leaders among motorcycle manufacturers. When the "golden twenties" ended and the worldwide economic crisis set in, one competitor after the other closed down in the USA. Even Indian gave up their business in 1953, Harley-Davidsons eternal and last adversary among the American large-scale manufacturers. Nevertheless, the monopoly in their own country was not enough to save the company from some lean years. The aftermath of WWII caused the export markets to collapse, and the machines built by Triumph, BSA and Norton became increasingly popular especially with the younger generation of motorcyclists. Not only were those British bikes cheaper, they also were more manoeuvrable than the sedate iron from Milwaukee. But Harley found an answer in the K model (later to become the Sportster). Furthermore, the rigid frame heavyweights finally received their counterpart in 1958 with the Duo Glide that featured the long-awaited rear suspension. Harley once more got sales going again. In subsequent years, the company agreed to some transactions that didn't do it much good which brought them into desperate plight, and finally even forced those responsible to give up their positions. In 1969, Harley-Davidson was taken over by the conglomerate AMF (American Machine & Foundry), a move that freed some means for new developments. However, with rigid savings in production costs and the inferior quality that accompanied this step, the new owners lastingly ruined the good reputation of Harley-Davidson motorcycles. When AMF had lost interest in Harley, thirteen managers from the old ranks seized the opportunity and bought back "their" company in 1981. From then on, the way ahead was clear: turning the motor company straight into what it is today. Shortly before the 100th anniversary in 2003, the renowned US business magazine "Forbes" awarded Harley-Davidson the title of "Company of the Year."

PICTURES
ARE
ALLOWED
Cameras & Film

PLEASE
DO NOT
TOUCH
OR
SIT ON
MOTORCYCLES

1907
Restored
Straptank
Harley-Davidson

Graciously on loan to the museum

RIDE EASY

Regarding motorcycles as much more than just a means of locomotion is a long-standing tradition. Long before "Easy Rider" arrived in the cinemas, bikes were already being "chopped". Rebuilt, that is, to make them look cooler and go faster. But it took that Oscar-winning screen epos to ride the chopper into the heads of the masses like nothing before. "Ride easy!" was the slogan from then on. And every one of the "young savages" dreamed of riding into the sunset on a long-fork machine like "Captain America".

Easy Rider was instrumental in kindling the desire for individually designed motorcycles. We today regard the choppers and their predecessors – called bobbers – as something like the forefathers of custom bikes, the currently used collective term for all kinds of converted and rebuilt machines. An engine, transmission, a tank, two wheels and a frame holding it all together, that's about all a chopper needs. The attraction is in combining those few parts in ever new ways.

Although the film heroes rode rebuilt Harley-Davidsons, the company didn't have any economic benefit from this, since the basis for the choppers were older, used machines and never new bikes. Harley-Davidson therefore took the decision to dissociate themselves from those "yobbos" and rocker gangs who turned into the upright citizen's nightmare on their "hot rodded motorcycles". Later on, however, the marketing strategies very successfully used the image of the outlaw machine. Almost from the start, all kinds of manufacturers of accessories found good income on the ground the chopper culture had prepared. A whole industry developed that with its parts in very diverse variations made it possible to build a complete motorcycle in the Harley look without as much as a single screw from the company in Milwaukee. Still, real customs like the bobbers and choppers of the first years are anything but construction kit bikes, because nothing is as important in this scene as individuality. And that can still best be reached with as many parts as possible that are not found in any catalogue, regardless of whether you build it yourself, or, as is often the case today, you arrange for a professional motorcycle builder.

EASYRIDERS
Southern Style

NEW HEROES

The movie "Easy Rider" was the original and main reason for the enthusiastic approach to individual motorcycles. Yet new heroes, as it were, were coined by reality TV that broadcast shows like "American Chopper", "Great Biker Build-Off" or "Texas Hardtails". Some motorcycle builders have actually become TV stars. With a view to the multimillion audience, they are in the public eye like never before. Meanwhile, even those kids who otherwise are more in love with their computers are interested in the hot machines. And in the guys that build them!

Everything started with "Motorcycle Mania" in 2001, a documentary about Jesse James broadcast by Discovery Channel. No one had expected the show to get hit quotas. The automobile and motorcycle builder from California became an idol. For Jesse James, what followed was "Motorcycle Mania II and III" and the series "Monster Garage" with countless episodes. Furthermore, Discovery Channel brought father and son Teutul, a very successful team, to the race in "American Chopper". Naturally, other channels tried to counter, and thus master builder Rick Fairless from Dallas got his own series on SPEED Channel: "Texas Hardtails".

Similar to the "Big Brother" concept, the motorcycle builders for reality productions are followed by cameras during their work and occasionally in their private life, too. In terms of entertainment value, the individual seasons are not inferior to conventional TV series. Of a somewhat different kind is the "Great Biker Build-Off", also a very successful format on Discovery Channel. 2006 saw the fifth season of this blockbuster. Two motorcycle builders have a competition to create a machine in front of running cameras. The audience decides on the winner at one of the great American biker meetings. From the ranks of Build-Off participants, Billy Lane and Indian Larry, who had a fatal accident in 2004, gained a status that can definitely be compared to that of rock stars. More recently, Billy Lane has also been cause for enthusiasm at US motorcycle meetings away from the screen. During his "Blood, Sweat & Gears Tour", he builds motorcycles as a kind of live show, supported by the best builders in the scene. The audience loves these shows. The "Teutuls" recently presented another stage performance to the crowds, their "America Tour".

Some of the machine screw shows found their way onto television screens worldwide. But although there are some very high-class motorcycle builders especially in Europe, Australia and Japan, those new heroes already mentioned with few exceptions are all from the USA. In the 2006 season of the "Great Biker Build-Off", a European, Marcus Walz, for the first time won one of the Discovery contests, which will probably contribute to increase this German's popularity who had already been successful in the US custom business. Not least because in his capacity as a Build-Off champion, he may challenge a new opponent for the next round, and will therefore automatically get another appearance on Discovery.

Rick Fairless

WOODSTOCK

HAPPENINGS

The very first biker meetings in the USA already evolved around historical motorcycle sports. Over the years, some of those originally smaller meetings turned into over-sized events mostly attended by Harley riders. From the 1970s onwards, there was a growing Harley scene in Europe, too. Furthermore, other parts of the globe like Australia, Japan and South Africa fell victim to the Harley and custom bike virus. Even faraway from the cradle of the Milwaukee cult, many regional and supra-regional events developed in the course of time. Bikers have therefore for a long time been able to attend such happenings on practically all shores of the oceans.

The most popular and nowadays largest events worldwide have always been the ones in Daytona/Florida and Sturgis/South Dakota, both of which have taken place for more than half a century. There are a number of other US events of considerable extent, like the rallies in Laconia/New Hampshire and Myrtle Beach/South Carolina as well as Laughlin River Run/Nevada, to name but a few.

A meeting that might be compared to the American mega-events is the meeting at Lake Faaker in the Austrian province of Kärnten that has grown in size since the late 1990s. Beyond the European Bike Week there are some other important, and partly much older European events. The Federation Harley-Davidson Club Europe (FH-DCE), for example, has been holding the Super Rally at different venues since the mid-1970s.

Harley-Davidson themselves called the Harley Owners Group (H.O.G.) into being in 1983, and a number of different events world-wide are their doing. The company especially took the widespread Harley enthusiasm into account on the occasion of its 100th anniversary. Called the Open Road Tour, it took place in 2003 with a costly event series in, among other cities, Toronto, Mexico City, Sydney, Tokyo, Barcelona and Hamburg. The gigantic birthday party in Milwaukee was the eventual finale. Biker convoys rode towards the city in the so-called Ride Home from all directions and from all parts of the USA.

Despite all those mega-events with several 100,000 visitors each, many bikers continue to value the much more personal atmosphere of smaller meetings. Special mention should be made of the parties thrown by motorcycle clubs that are often much more freewheeling and wild than the highly official events.

The reason for biker meetings can be far more diverse than riding motorcycles, having fun and music, shows and competitions. It is nothing unusual in the Harley scene to meet at benefit events for different charities. The larger events of this kind have been taking place in California and Switzerland for years, the very popular Love Rides. Furthermore there are other meetings for very specific reasons, like the Rolling Thunder Rally for which approximately half a million bikers ride to Washington D.C. to remember soldiers killed in action.

NO GANG PATCHES

1%er

BORN TO BE WILD

"Born To Be Wild" – no doubt THE ultimate biker hymn. And there was no title for this book everyone concerned would have found more appropriate than the catchy chorus line from that Steppenwolf song, although, admittedly, it is a rather dated cliché nowadays. After all, there are more leisure time bikers than true outlaws riding Harleys and similar machines; some mockingly call them "evening" or "weekend rockers". Whatever things look like for those wild bikers, they surely caused quite a stir early on.

Lin Kuchler of the AMA (American Motorcyclists Association) was often quoted, and his statement the subject of many a discussion. He claimed that only one percent of all motorcycle riders were hoodlums and trouble makers, but that this small group was capable to destroy the reputation of all the other motorcyclists. He was talking about those wild, beardy and tattooed guys who attracted attention on the 4th of July weekend in 1946 with their souped-up Harleys, Indians, Triumphs, Nortons and BSAs around the motorcycle races in Hollister, California. Those blokes didn't just look like they were reckless, they also had far more "fun" in the bars and on the little town's main street than the authorities and honest citizens generally like to see. However, nothing truly dramatic happened apart from a few scratches and a little material damage. But the posturing on the noisy machines, the drinking and vulgarity were just what the sensation-hungry press and eventually even Hollywood had been waiting for, because "The Wild One" was inspired by the Hollister rampage, followed by several more movies with pretty much the same kind of plot. The result: Joe Bloggs now believed that he knew exactly who was threatening him. At the same time, the yobs had finally found their role models and strove to emulate them. However, the origins of outlaw bikers in the USA cannot be traced back to a youth sub-culture like in England or Germany, for instance. Instead, from the mid-1930s onwards, returning American soldiers began to call each other "brother" and continued to live comradeship in motorcycle clubs.

Against the backdrop described above, the 1% sign has become a still valid symbol for outlaw bikers. Those wearing such a patch thus pronounce their membership in one of the corresponding groups of motorcyclists and the philosophy of life it reflects.

BIKER INK

Yes, it does hurt! But what's pain compared to the magic whirring of the tattoo gun? The passion of collecting pictures on skin! Tattoos belong to many bikers just as the machine does. And love for motorcycles can go damned far at times. The Harley-Davidson logo is likely to be the most often tattooed trademark world-wide. But apart from that, biker ink placed under the skin shows as many facets as the motorcycle world itself.

Often those images serve as lasting souvenirs, are inspired by special events or personal experiences. They can, of course, also show ones preferences, fantasies and desires or simply be extravagant ornamentation. Sometimes, tattoos are a sign of belonging to a committed group, or even show coded symbols only those in the know can read.

Some years ago, tattoos often were nothing but botched up amateur work, there were few professional tattooists and little professional equipment. Now that tattoos have become widely accepted among all social classes for some years, tattooing has been the object of a real wide-ranging boom, which also led to a rapid development in the art of tattooing. Skin images have long since been accepted as an individual form of art, and even Harley-Davidson acknowledges this development. The company, for instance, organised tattoo competitions around large events like the Daytona Bike Week or the Sturgis Rally. But no matter whether it is possibly prize-winning or not, biker tattoos are certainly worth a look in all their variations.

BACK
TO THE ROOTS

An individual motorcycle is of extremely high value for many bikers. Over time, rebuilding and converting them has become ever more expensive. Modern high-end customising has come up to a level that can practically only be reached by absolutely professional motorcycle builders. As if they followed a secret sign, quite a few people have now tired of the exaggerated show bikes. "Back to the roots" is the motto one often hears these days.

"Back to the roots" by no means intends rebuilding in an old style that has to be plain and simple. On the contrary, just look at the bikes of the Indian Larry Legacy, simply abounding with craftsmanship. In the work of Paul Cox and Keino, the style of that unique old style master builder from New York lives on after his tragic death in an accident. But not just the bikes in very early chopper style have regained their popularity today, the bobbers also celebrate a magnificent revival. Those are the lean machines from the 1940s and 50s with balloon tyres, short forks, fat bob tanks and bicycle-style saddles.

Rock'n'Roll in their ears and images from old "yobbo" movies before them, people build more and more of those spartan-looking bikes. Motorcycles that don't have rear tyres of record-breaking width, lots of billet parts and mega-expensive paint jobs. Bikes that rather remind one of those machines the anti-establishment figures were riding, i.e. motorcycles that were rebuilt at a time one might call the early days of customizing. It was very simple then to make a machine "hot": you simply removed all the parts that weren't absolutely necessary, not just because it looked much cooler, but also because the bike was lighter that way. The huge rear fender went out, the smaller front mudguard went to the rear. The engine was "souped up" and a couple of open exhaust pipes added. Last not least, a hot rod paint job and off you went!

Alright, of course it's not quite so easy for modern bobbers. Generally, what people are looking for today is a new build from scratch rather than just removing things. And so the motorcycle builders with their considerable skill and a number of clever tricks refine pure old style. Still, in principle, people have gone back to the old school in many ways and remembered that less is often more!

ABOUT THE AUTHORS

After completing his studies at Ruhr-Universität Bochum, Germany, **MICHAEL STEIN** continued his education with a post-graduate course as a technical editor. He later on turned to journalism and worked for the German edition of the Swedish cult-magazine "Wheels" as well as for the leading European magazine on US automobiles, "Chrome & Flames". To date, Michael Stein has been chief editor for the European edition of the American motorcycle magazine "Easyriders" for almost 10 years, a time in which the Harley-Davidson motorcycle enthusiast developed into an extremely knowledgeable expert on the European custom and biker scene. At the same time, he is also a US specialist and visited every important motorcycle event on his journeys through more than 40 American states. Michael Stein's focus is on biker lifestyle photography, and this is the reason why in addition to his text contributions, there is also a number of his fascinating pictures to be found in this earBOOK.

MICHAEL LICHTER started photographing the biker lifestyle and custom bikes in the 1970s. Since 1982, he has owned his own studio in Boulder, Colorado. Internationally renowned as a top photographer, he became known to a larger audience mainly through his work for "Easyriders", a magazine that became an American original in its more than 35 years of publication. Furthermore, Michael Lichter's unique photos have illustrated seven other books and have contributed to relevant publications such as Willie G. Davidson's book on the 100th anniversary of Harley-Davidson. Since 2000, Michael Lichter's photographic art has been exhibited in more than 15 galleries and museums and was covered in several US television shows. While his work has taken him around the world, this earBOOK shows Michael Lichter's unique and very impressive photos of the great American biker meetings in Daytona, Sturgis, Laconia and Myrtle Beach.

VORWORT

Fach- und Sachbücher über Harleys, Custombikes sowie über die zugehörige Szene gibt es viele. Eher künstlerisch einzustufende Bände – mit Fotos, die das Thema betont emotional angehen – jedoch weitaus weniger. Aus der Idee, derartiges gar noch mit einer passenden CD-Musikkollektion zu krönen, entstand „Born To Be Wild". Ein earBOOK, in dessen reichhaltige Bildstrecke einzelne kurze Beiträge zu Wissenswertem und Interessantem aus der Harley-Szene eingefügt sind.

Die folgenden Seiten zeigen einen Querschnitt der beeindruckenden Fotokunst von Michael Lichter, bekannt vor allem durch seine langjährige Arbeit für das amerikanische Kultmagazin „Easyriders" sowie verschiedene einschlägige Bücher. Entstanden sind diese Bilder allesamt dort, wo auch das Urgestein Harley-Davidson herkommt. Die Begeisterung für die traditionsreiche US-Motorradmarke und der damit einhergehende Lifestyle sind aber schon lange kein rein amerikanisches Phänomen mehr. So schien es nur allzu naheliegend, dieses earBOOK mit einigen Fotos abzurunden, die ich während meiner bald zehnjährigen Tätigkeit als Chefredakteur der Europaausgabe von „Easyriders" gemacht habe.

Auch wenn die Bilder in diesem Buch von verschiedenen Kontinenten kommen, so haben sie auf alle Fälle eines gemeinsam: Sie zeigen eine Szene, die nicht nur geographisch äußerst breitflächig, sondern im wahrsten Sinne des Wortes vielschichtig ist. Auf Harleys trifft man längst nicht mehr nur eingeschworene Enthusiasten an. Und den wilden Um- und Aufbauten gehört keinesfalls allein das Herz von Outlaws. Beachtlicherweise sind teilweise selbst Klassenunterschiede im Zeichen der großvolumigen V-Twins auf der Strecke geblieben. Denn zu den vielen regelmäßig stattfindenden Events fährt der oft ins Feld geführte Zahnarzt tatsächlich genau so gerne wie der Schlosser und die Bankangestellte. Egal ob waschechter Rocker oder Freizeit-Rebell... Sie alle fühlen sich, wenn auch oft nur für ein Wochenende: „Born To Be Wild"!

Michael Stein

Michael Stein
- Chefredakteur Easyriders, Europe -

MUSIC FOR EASY RIDERS

Von deftigem Blues, Countryklängen und Southern Rock bis hin zu beinharten Metaltönen reicht der Sound, auf den Biker im wahrsten Sinne des Wortes „abfahren". Der Brückenschlag zwischen Musik und Motorrädern ergibt sich nahezu zwangsläufig. Die Bands haben den Rock, die Bikes den Roll. Beides zusammen ergibt Rock'n'Roll! Auf den Punkt gebracht: Music for Easy Riders.

Spätestens mit dem Kinofilm „Easy Rider" (1969) wurden Musik und Motorräder untrennbar verlinkt. Steppenwolfs „Born To Be Wild" aus dem Soundtrack mutierte zu DER Bikerhymne schlechthin. Und für Motorradfahrer, die aus der Norm fallen wollten, galt fortan eine Harley-Davidson endgültig als DAS Bike. Denn Peter Fonda und Dennis Hopper fuhren in „Easy Rider" nicht irgendwelche Maschinen, sondern umgebaute Harley-Panheads.

Obwohl „Easy Rider" zum mit Abstand populärsten Bikerfilm aller Zeiten wurde, darf „The Wild One" keinesfalls unerwähnt bleiben. Wenn auch Triumph fahrend, mimte Marlon Brando bereits 1954 auf der Leinwand den Boss einer Motorradgang. Der Streifen zog nicht nur die „Halbstarken" in seinen Bann, sondern beeinflusste gleichzeitig viele Musiker. Und das, obwohl es sich gar nicht um einen Rock'n'Roll-Movie handelte. Aber „The Wild One" hatte den magischen Sound der Motoren! Fehlte eigentlich nur noch die richtige Musik. Lang ist die Liste der über die Jahre hinweg entstandenen Motorsongs. „Take The Highway" von der Marshall Tucker Band, Canned Heats „On The Road Again", Molly Hatchets „Kickstart To Fredoom", Saxons „Motorcycle Man" oder „Rockin' Down The Highway" von den Doobie Brothers seien nur als Beispiele genannt.

Musik für Biker muss längst nicht unbedingt allein vom Motorradfahren handeln. Die Tracks sollten vielmehr ganz einfach ehrlich und handgemacht sein. Mit reichlich Feeling und einem Sound, der wie die mächtigen V-Twins die sprichwörtlichen „Good Vibrations" hat. Ähnlich der Company aus Milwaukee hetzen die von Bikern favorisierten Bands keinesfalls bedingungslos dem technischen Fortschritt nach. Letztendlich bedarf es weder der Perfektion neuzeitlicher Computerbeats, noch einer technisch perfekten Maschine. Es sind andere Dinge, die zählen. „If I have to explain, you wouldn't understand!", lautet ein weit verbreiteter Harley-Biker-Spruch. Vielleicht muss ja nach dem Hören der vier CDs dieses earBOOKs ohnehin nichts mehr erklärt werden…

MILWAUKEE IRON

1903 rollte in Milwaukee das erste Bike aus dem Holzschuppen von Bill Harley und den Brüdern Arthur und Walter Davidson. Die Einzylindermaschine glich allerdings noch eher einem motorisierten Fahrrad. Bereits 1909 folgte aber, was im Laufe der Jahre zum Mythos werden sollte: der 45°-V-Twin. Unaufhaltsam war das Streben von Harley und den Davidson-Brüdern, zuverlässige zweirädrige Fortbewegungsmittel zu bauen. Im Rekordtempo gelang die Entwicklung zur weltberühmten Motor Company. Bevor „Milwaukee iron" zum absoluten Kult wurde, gab es jedoch auch derbe Rückschläge.

Schon 1920 hatten die emsigen Pioniere die weltweite Marktführerschaft unter den Motorradherstellern erobert. Besonders in Folge der Ende der „Goldenen Zwanziger" einsetzenden Weltwirtschaftskrise strich in den USA ein Konkurrent nach dem anderen die Segel. 1953 machte schließlich sogar Indian die Tore dicht, Harley-Davidsons ewiger und letzter Widersacher im Lager der amerikanischen Großserienhersteller. Dennoch konnte die Monopolstellung im eigenen Lande die Company keinesfalls vor mageren Zeiten bewahren. Die Nachwirkungen des zweiten Weltkriegs hatten die Exportmärkte einbrechen lassen. Zudem wurden vor allem bei den jüngeren Motorradkäufern die Maschinen von Triumph, BSA und Norton immer beliebter. Die britischen Bikes kosteten nicht nur weniger, sondern waren auch weitaus agiler als die behäbigen Eisen aus Milwaukee. Doch Harley gelang es, mit dem K-Modell – der späteren Sportster – zu antworten. Zudem erhielten die Starrrahmenschwergewichte 1958 mit der Duo Glide ihr längst überfälliges hinten gefedertes Pendant. Harley hatte den Absatz wieder in Schwung gebracht. In der Folgezeit ließ sich die Company aber auf Transaktionen ein, die ihr nicht gut taten. Das führte in die absolute Misere, und schließlich waren die Verantwortlichen gar gezwungen, das Zepter aus der Hand zu geben. 1969 wurde Harley-Davidson vom Mischkonzern AMF (American Machine & Foundry) übernommen. Damit standen Mittel für neue Entwicklungen bereit. Doch mit rigorosen Einsparungen bei den Produktionskosten und dem damit einhergehenden Qualitätsverlust verspielten die neuen Eigner nachhaltig den guten Ruf der Harley-Davidson-Motorräder. Als AMF das Interesse an Harley verloren hatte, nutzten dreizehn Manager aus alten Reihen die Gunst der Stunde und kauften 1981 „ihre" Firma zurück. Von da an waren die Weichen gestellt, die Motor Company auf geradem Wege zu dem zu machen, was sie heute ist. Noch kurz vor dem 100jährigen Jubiläum 2003 zeichnete das renommierte US-Wirtschaftsmagazin „Forbes" Harley-Davidson als „Company of the Year" aus.

RIDE EASY

In Motorrädern weit mehr als reine Fortbewegungsmittel zu sehen, hat eine weit zurückreichende Tradition. Schon lange bevor „Easy Rider" in die Kinos kam, wurden Bikes „gechoppt", also umgebaut, damit sie cooler aussahen und schneller wurden. Aber erst das Oscar-prämierte Leinwandepos ließ den Chopper wie nichts zuvor in das Bewusstsein einer breiten Masse rollen. „Ride easy!" lautete fortan das Motto. Und jeder „junge Wilde" träumte davon, auf einem Langgabler wie „Captain America" in den Sonnenuntergang zu fahren.

In hohem Maße weckte „Easy Rider" das Verlangen nach individuell aufgebauten Motorrädern. Aus heutiger Sicht sind Chopper und deren Vorgänger – Bobber genannt – so etwas wie die Urahnen der späteren Custombikes, dem aktuell gebräuchlichen Sammelbegriff für Um- und Aufbauten unterschiedlichster Art. Ein Motor, ein Getriebe, ein Tank, zwei Räder und ein Rahmen, der alles zusammenhält, vielmehr braucht ein Chopper nicht. Der Reiz liegt darin, diese wenigen Teile in immer wieder neuer Machart zu kombinieren.

Auch wenn die Filmhelden umgebaute Harley-Davidsons fuhren, so brachte das der Company seinerzeit wirtschaftlich überhaupt nichts. Dienten als Basis für die Chopper doch alte Gebrauchtmotorräder und keinesfalls neue Bikes. Harley-Davidson distanzierte sich denn auch bewusst von den „Halbstarken" und Rocker-Gangs, die auf ihren wilden „Öfen" der Schreck des braven Bürgers waren. Das Image der Outlaw-Machine machte man sich in den Marketingstrategien erst später überaus erfolgreich zunutze. Früh wuchsen auf dem Nährboden der Chopper-Kultur aber alle möglichen Zubehöranbieter heran. Es entstand eine Industrie, die es mit ihren Teilen in unterschiedlichsten Varianten möglich machte, ein komplettes Motorrad im Harley-Look aufzubauen, ohne dass dabei auch nur eine einzige Schraube von der Company aus Milwaukee stammen müsste. Dennoch sind echte Customs genauso wie die Bobber und Chopper der ersten Stunde alles andere als Baukasten-Bikes. Denn Individualität steht in der Szene über allem, und die lässt sich immer noch am ehesten mit möglichst vielen Teilen erreichen, die in keinem Katalog zu finden sind. Sei es nun, dass man selbst Hand anlegt oder wie heute vielfach üblich, einen professionellen Motorradbauer beauftragt.

NEW HEROES

Ursprünglich war vor allem der Kinofilm „Easy Rider" der Motor für die Begeisterung am individuellen Motorrad. Sozusagen neue Helden hat jedoch das Reality-TV mit Sendungen wie „American Chopper", dem „Great Biker Build-Off" oder „Texas Hardtails" hervorgebracht. Einige Motorradbauer sind zu regelrechten Fernsehstars geworden. Angesichts des Multimillionenpublikums wird ihnen eine bis dato nicht gekannte Öffentlichkeit zuteil. Mittlerweile begeistern sich gar die sonst eher in ihre Computer vernarrten Kids für „heiße Öfen". Und nicht weniger für die Typen, die sie bauen!

Angefangen hatte alles 2001 mit „Motorcycle Mania", einer Dokumentation im Discovery Channel über Jesse James. Völlig unerwartet wurde die Sendung zum absoluten Quotenrenner und der Auto- und Motorradschrauber aus Kalifornien zum Idol. Für Jesse James folgten „Motorcycle Mania II und III" sowie in ungezählten Episoden die Serie „Monster Garage". Weiterhin brachte der Discovery Channel mit „American Chopper" das überaus erfolgreiche Vater-Sohn-Gespann der Teutuls an den Start. Klar, dass andere Sender konterten. So bekam beispielsweise Meisterschrauber Rick Fairless aus Dallas mit „Texas Hardtails" seine eigene Serie im SPEED Channel.

In „Big Brother"-Manier werden die Motorradbauer für die Reality-Produktionen bei ihrer Arbeit und teilweise auch privat von Fernsehkameras verfolgt. Was den Unterhaltungswert angeht, stehen die einzelnen Staffeln konventionellen TV-Serien in nichts nach. Etwas anders gestrickt ist der ebenso überaus erfolgreiche „Great Biker Build-Off" des Discovery Channel. 2006 ging der Blockbuster bereits in die fünfte Runde. Vor laufenden Kameras bauen jeweils zwei Motorradbauer eine Maschine um die Wette, und mittels Publikumsentscheid wird bei einem der großen amerikanischen Biker-Meetings der Sieger ermittelt. Aus der Riege der Build-Off-Teilnehmer haben vor allem Billy Lane und der 2004 tödlich verunglückte Indian Larry einen Status erreicht, der durchaus mit dem von Rockstars zu vergleichen ist. In jüngerer Zeit sorgt Billy Lane aber auch abseits der Mattscheibe bei US-Motorradtreffen für reichliche Begeisterung. Während seiner „Blood, Sweat & Gears Tour" baut er von einigen Top-Cracks der Szene unterstützt Motorräder in einer Art Liveshow, die beim Publikum bestens ankommt. Darüber hinaus haben die Teutuls mit ihrer „America Tour" neuerdings eine weitere Stage-Performance an den Start gebracht.

Mit großem Erfolg laufen mittlerweile weltweit verschiedene Schraubersendungen. Aber obwohl es vor allem auch in Europa, Australien und Japan äußerst hochkarätige Motorradbauer gibt, kommen besagte neuen Helden bisher nahezu allesamt aus den USA. Im Rahmen der 2006er-Staffel des „Great Biker Build-Off" hat mit Marcus Walz zum allerersten Mal jedoch ein Europäer einen der Discovery-Contests gewonnen. Damit dürfte die Popularität des in den USA bereits zuvor im Custombusiness erfolgreichen Deutschen weiter steigen. Das nicht zuletzt, weil er als Build-Off-Champion einen neuen Gegner für die nächste Runde herausfordern darf. Ein weiterer Discovery-Auftritt ist ihm somit automatisch beschert.

HAPPENINGS

In den USA entwickelten sich die allerersten Bikermeetings bereits im Umfeld des historischen Motorradsports. Im Laufe der Zeit mutierten einige dieser anfangs noch relativ kleinen Treffen zu übermäßig großen und vorrangig von Harley-Fahrern besuchten Events. Mit den Siebzigern beginnend prägte sich zudem in Europa immer deutlicher eine Harley-Szene aus. Darüber hinaus sollten weitere Teile des Globus wie etwa Australien, Japan und Südafrika vom Harley- und Custombike-Virus befallen werden. Auch fernab der Wiege des Milwaukee-Kults entstand über die Jahre eine Vielzahl regionaler und überregionaler Veranstaltungen. Somit können Biker längst auf nahezu allen Seiten der Ozeane entsprechende Happenings ansteuern.

Die bekanntesten und heute weltgrößten Meetings finden seit jeweils weit mehr als einem halben Jahrhundert in Daytona/Florida und Sturgis/South Dakota statt. Darüber hinaus gibt es etliche weitere US-Events beachtlicher Ausmaße. Genannt seien nur die Treffen von Laconia/New Hampshire und Myrtle Beach/South Carolina sowie der Laughlin River Run/Nevada.

Ein mit den amerikanischen Großveranstaltungen annähernd zu vergleichendes Meeting ist seit Ende der neunziger Jahre am Faaker See im österreichischen Kärnten herangewachsen. Über diese European Bike Week hinaus gibt es etliche weitere bedeutsame und teilweise erheblich ältere europäische Veranstaltungen. So wird etwa von der Federation Harley-Davidson Clubs Europe (FH-DCE) bereits seit Mitte der Siebziger an wechselnden Orten die Super Rally initiiert.

Harley-Davidson selbst rief 1983 die Harley Owners Group (H.O.G.) ins Leben, auf deren Konto weltweit verschiedene Events gehen. Der an allen möglichen Orten anzutreffenden Harley-Manie, hat die Company ganz besonders auch anlässlich ihres 100jährigen Jubiläums Rechnung getragen. Als Open Road Tour betitelt, machte man 2003 mit einer aufwändigen Veranstaltungsreihe unter anderem in Toronto, Mexico City, Sydney, Tokio, Barcelona und Hamburg Station. Das Finale war schließlich die gigantische Geburtstagsparty von Milwaukee. Diese wurde als sogenannter Ride Home sternförmig in mächtigen Konvois aus allen Ecken der USA angefahren.

Trotz der ganzen Mega-Events mit jeweils etlichen 100.000 Besuchern schätzen viele Biker aber nach wie vor auch die weitaus persönlichere Atmosphäre kleiner Zusammenkünfte. Besonders zu erwähnen sind die Parties der Motorradclubs, auf denen es oft viel ungezügelter und ausgelassener zugeht als bei den hochoffiziellen Events.

Über das Motorradfahren hinaus Spaß mit Musik, Shows und Wettbewerben zu haben, muss aber längst nicht allein der Anlass von Biker-Meetings sein. In der Harley-Szene sind unter anderem auch Benefizveranstaltungen zugunsten verschiedener wohltätiger Zwecke an der Tagesordnung. Die größten Events dieser Art finden mit den sehr populären „Love Rides" bereits seit vielen Jahren in Kalifornien und der Schweiz statt. Darüber hinaus gibt es weitere Treffen aus ganz bestimmten Beweggründen. So etwa die Rolling Thunder Rally, zu der jeweils rund eine halbe Million Biker nach Washington D.C. fahren, um gefallener Soldaten zu gedenken.

BORN TO BE WILD

„Born To Be Wild" ist fraglos DIE Bikerhymne schlechthin. Und für dieses Buch gab es keinen Titel, der allen Beteiligten hätte besser gefallen können, als der eingängige Refrain des Steppenwolf-Songs. Obwohl damit zugegebenermaßen heute eher ein Klischee bemüht wird. Schließlich sind auf Harleys und ähnlichen Maschinen längst weitaus mehr Freizeitbiker als waschechte Outlaws unterwegs. Spötter sprechen gar von „Feierabend-" oder „Wochenendrockern". Wie auch immer es um die Wildheit der Biker tatsächlich bestellt sein mag, die Gemüter erregten sich jedenfalls schon früh daran.

Viel zitiert und oft erörtert ist eine Äußerung Lin Kuchlers von der AMA (American Motorcyclists Association). Danach seien nur ein Prozent aller Motorradfahrer Rowdies und Unruhestifter. Diese kleine Gruppe aber sei im Stande, den Rest der Motorradfahrer in Verruf zu bringen. Die Rede war von jenen wilden, bärtigen und tätowierten Typen, die am Wochenende des 4. Juli 1946 mit ihren „frisierten" Harleys, Indians, Triumphs, Nortons und BSAs am Rande von Motorradrennen im kalifornischen Hollister für Aufsehen sorgten. Diese Kerle sahen nicht nur verwegen aus, sondern hatten in den Bars und auf der Hauptstraße des kleinen Städtchens weitaus mehr „Spaß" als Behörden und braven Bürgern im allgemeinen recht ist. Über körperliche Blessuren und Sachschäden hinausgehend, passierte aber nichts wirklich Dramatisches. Dennoch waren das Imponiergehabe auf den lauten Maschinen, die Saufgelage und Pöbeleien ein gefundenes Fressen für die sensationslüsterne Presse und letztendlich gar für Hollywood. Denn „The Wild One" ist durch die Randale von Hollister inspiriert, und etliche weitere Streifen nach gleichem Strickmuster sollten folgen. Das Ergebnis: Der Normalverbraucher glaubte fortan ganz genau zu wissen, von wem er bedroht wird. Gleichzeitig hatten die „Halbstarken" endgültig ihre Vorbilder gefunden, denen sie nacheifern konnten. Dennoch gehen die Ursprünge der Outlaw-Biker in den USA keinesfalls wie etwa in England oder Deutschland auf eine Jugendkultur zurück. Vielmehr waren es schon ab Mitte der 30er Jahre heimkehrende amerikanische Soldaten, die sich untereinander als „Brothers" bezeichneten und ihre Kameradschaft in Motorradclubs weiterleben ließen.

Vor dem beschriebenen Hintergrund ist das 1%-Zeichen zu einem Symbol geworden, das für Outlaw-Biker steht und bis heute erhalten blieb. Die Träger des Patch bekennen sich damit zu entsprechenden Gruppierungen von Motorradfahrern und der damit verbundenen Lebensphilosophie.

BIKER INK

Ja, es tut weh! Doch was ist schon Schmerz gegen das magisch anziehende Surren der Tattoo-Gun? Die Leidenschaft Hautbilder zu sammeln! Tätowierungen gehören zu vielen Bikern wie die Maschine. Die Liebe zum Motorrad kann dabei verdammt weit gehen. Das Harley-Davidson-Logo dürfte wohl das mit Abstand meisttätowierte Markenzeichen der Welt sein. Darüber hinaus ist die unter die Haut gebrachte Biker-Tinte aber so facettenreich wie die Motorradszene selbst.

Oft dienen die Bilder als bleibende Souvenirs, sind inspiriert von besonderen Ereignissen oder persönlichen Erlebnissen. Sie können natürlich auch eigene Vorlieben, Fantasien und Wünsche aufzeigen oder ganz einfach extravaganter Schmuck sein. Manchmal stehen Tätowierungen für die Zugehörigkeit zu einer eingeschworenen Gemeinschaft, zeigen gar verschlüsselte Symbole, die nur Eingeweihte zu deuten wissen. Früher waren Tattoos nicht selten stümperhafte Sticheleien, und es gab nur wenige professionelle Tätowierer und ebensolche Geräte. Mit der nun schon seit geraumer Zeit erfolgten weitestgehenden Akzeptanz von Tattoos in allen Gesellschaftsschichten hat das Tätowieren auf breiter Ebene einen wahren Boom erfahren. Das führte nicht zuletzt zu einer enormen Entwicklung des Tätowiererhandwerks. Die Hautbilder sind längst als eigenständige Kunstform anerkannt. Selbst Harley-Davidson würdigt diese Entwicklung. So gab es bereits von der Company durchgeführte Tattoowettbewerbe während großer Veranstaltungen wie etwa der Daytona Bike Week oder der Sturgis Rally. Doch egal, ob nun preisverdächtig oder nicht, äußerst beachtenswert sind Biker-Tattoos in all ihren Variationen auf jeden Fall.

BACK TO THE ROOTS

Das individuelle Motorrad hat für viele Biker einen äußerst hohen Stellenwert. Mit der Zeit sind die Um- und Aufbauten deshalb immer aufwändiger geworden. Zeitgemäßes High-End-Customizing hat ein Niveau erreicht, dem nahezu nur absolut professionelle Motorradbauer gerecht werden können. Wie einem geheimen Zeichen folgend, ist man neuerdings aber vielfach der überzogenen Show-Bikes überdrüssig geworden. „Back to the roots", lautet das heute oft gehörte Motto.

„Back to the roots" meint jedoch keinesfalls, dass Umbauten im alten Stil unbedingt anspruchslos sein müssten. Ganz im Gegenteil – man sehe sich beispielsweise die von Handwerkskunst nur so strotzenden Bikes der Indian Larry Legacy an. Mit der Arbeit von Paul Cox und Keino lebt der Stil des einzigartigen New Yorker Oldstyle-Masterbuilders nach dessen tragischem Unfalltod weiter. Es sind aber längst nicht allein die Bikes im ganz frühen Chopperstil, die wieder äußerst beliebt sind. Vielmehr feiern derzeit auch die Bobber ein grandioses Revival. Also jene „abgespeckten" Maschinen der 40er und 50er Jahre mit Ballonreifen, kurzen Gabeln, Fat Bob-Tanks und fahrradmäßigen Sätteln.

Mit Rock'n'Roll in den Ohren und Bildern aus alten „Halbstarken"-Filmen vor Augen, werden zunehmend spartanisch anmutende Bikes gebaut. Motorräder, die nicht über Hinterreifen von Rekordbreite, reichlich maschinengefräste Aluteile und megaaufwändige Lackierungen verfügen. Bikes, die vielmehr an das erinnern, womit früher die Bürgerschreckfraktion unterwegs war. Also Motorradumbauten aus einer Zeit, die man als die Kindertage des Customizing bezeichnen könnte. Damals war es ganz simpel, eine Maschine „heiß" zu machen: Nicht nur des cooleren Aussehens, sondern auch des Gewichts wegen, wurden einfach alle Teile abgebaut, die nicht unbedingt notwendig waren. Das ausladende Heckschutzblech wanderte auf den Müll, der kleinere vordere Schmutzfänger nach hinten. Der Motor wurde „frisiert" und ein Paar offene Auspuffrohre angebaut. Last not least ein Hot-Rod-Anstrich... und ab ging die Post!

Ganz so einfach macht man es sich bei den zeitgemäßen Bobbern natürlich nicht. Von Grund an Aufbauen ist heute durchweg eher angesagt als bloßes Abbauen. Dabei verfeinern die Motorradbauer mit reichlich Können und allerhand ausgeklügelten Tricks den puren Oldstyle. Dennoch hat man vom Prinzip her vielfach zur alten Schule zurückgefunden und sich darauf besonnen, dass weniger oft mehr ist!

ÜBER DIE AUTOREN

MICHAEL STEIN absolvierte nach seinem Studium an der Ruhr-Universität Bochum eine weiterführende Ausbildung zum Technischen Redakteur. Mit der Arbeit für die deutsche Ausgabe des schwedischen Kult-Magazin „Wheels" sowie der führenden europäischen US-Car-Zeitschrift „Chrom & Flammen" stieg er später in den Journalismus ein. Mittlerweile ist Michael Stein seit nahezu 10 Jahren Chefredakteur der Europaausgabe des amerikanischen Motorradmagazins „Easyriders". Während dieser Zeit entwickelte sich der Harley-Davidson-Enthusiast zum exzellenten Kenner der europäischen Custom- und Biker-Szene. Gleichzeitig ist er aber auch US-Spezialist und hat auf Reisen durch über 40 amerikanische Bundesstaaten alle maßgeblichen Motorradveranstaltungen besucht. Ein besonderer Schwerpunkt von Michael Stein ist die Biker-Lifestyle-Fotografie, weshalb über die Textbeiträge hinaus auch eine Reihe seiner faszinierenden Bilder den Weg in dieses earBOOK fanden.

MICHAEL LICHTER begann bereits in den 70er Jahren den Biker-Lifestyle und Custom-Bikes zu fotografieren. Seit 1982 betreibt er sein eigenes Studio in Boulder, Colorado. International als Top-Fotograf bekannt wurde er vor allem durch seine Arbeit für das in über 35 Jahren zum amerikanischen Original avancierten Magazin „Easyriders". Darüber hinaus sind seine einzigartigen Fotos in weiteren sieben Bildbänden sowie einschlägigen Publikationen erschienen, wozu unter anderem auch Willie G. Davidsons Buch zum 100-jährigen Harley-Jubiläum gehört. Michael Lichters Fotokunst wurde seit 2000 in über 15 Galerien und Museen gezeigt und war zudem Thema mehrerer US-Fernsehsendungen. Während ihn seine Arbeit nahezu in die ganze Welt führt, zeigt dieses earBOOK vorrangig seine unverwechselbaren und äußerst beeindruckenden Fotos von den großen amerikanischen Biker-Meetings in Daytona, Sturgis, Laconia und Myrtle Beach.

CD 01
BORN TO BE WILD

01 **Steppenwolf – Born To Be Wild*** 03:26
(Mars Bonfire) · Manitou Music/Universal-MCA Music Ltd./Universal-MCA Music Publ. GmbH

02 **Motörhead – Born To Raise Hell** 5:41
(Kilmister/Campbell/Burston/Dee) · (P) 1999 Steamhammer, a division of SPV GmbH · ISRC: DE-A45-99-01100
With courtesy of SPV GmbH · Taken from the album "Everything louder than everyone else"

03 **The Doobie Brothers Revisited – Rockin' Down The Highway*** 3:17
(Charles Thomas Johnston) · Warner-Tamerlane Publ. Co./Warner Bros. Inc./Neue Welt MV GmbH & Co. KG

04 **Saxon – Midnight Rider (live)*** 5:21
(Biff Byford/Stephen Dawson/Peter Francis Michael Gill/Graham Oliver/Paul Anthony Quinn)
Saxongs/Carlin Music Corp/Greenhorn MV GmbH & Co. KG

05 **The Marshall Tucker Band – Southern Woman** 07:56
(Toy T. Caldewel, Jr) · Spirit One Music/Marshall Tucker Publ. Co./Wintrup MV Walter Tucker Publ. Co.)

06 **Jimi Hendrix – Drivin' South** 04:45
(Curtis McNear) · PPX Publishing (BMI)

07 **Judas Priest – Hell Bent For Leather** 03:49
(Glen Tipton) · EMI Songs Ltd. · (P) 1998 Priest Music under exclusive license, 1998 Steamhammer, a division of SPV GmbH
ISRC: DE-A45-98-05530 · With courtesy of SPV GmbH · Taken from the album "98 Live-Meltdown"

08 **Bachman-Turner Overdrive – Roll On Down The Highway (live)** 04:07
(Randy Bachman/Charles Fred Turner) · Randy Bachman Music/Sony-ATV Songs LLC/Sony-ATV Music Publ.Germany GmbH

09 **The Marshall Tucker Band – Fly Eagle Fly** 04:25
(Toy T. Caldwell, Jr.) · Spirit One Music/Marshall Tucker Publ. Co./Wintrup MV Walter Holzbaur

10 **Carry & Ron – Far Away From Home** 03:26
(Brian Cadd/Ron Traub) · Fairy Dust Music/Autobahn Musik GmbH/MV Intersong GmbH & Co. KG

11 **The Guess Who – American Woman*** 05:01
(Randolf Charles Bachman/Burton Cummings/Jim Kale/Garry Peterson) · Shillelagh Music Co./Bug Music Inc./Bug Music Musikverlagsgesellschaft mbH

12 **Eric Burdon – Devil Run** 03:22
(John Bundrick) · Cayman Music/MCPS Europe/ASCAP USA · (P) 2006 SPV Recordings, a division of SPV GmbH
ISRC: DE-A45-05-06190 · With courtesy of SPV GmbH · Taken from the album "Soul of a man"

13 **Samson – Driving With ZZ** 04:32
(Paul Samson/Christopher Robin Aylmer/Nicky Moore/Peter Jupp) · Rondor Music London Ltd./Rondor-Music Inc./Rondor MV GmbH

14 **Allman Brothers Band – Ramblin' Man** 03:42
(Richard Betts) · (P) 1973 Castle Copyrights · Licensed courtesy of Sanctuary Records Group Ltd.

* New recordings by original artists
Tracks 1, 3, 4, 6, 8, 10, 11 & 13 are licensed from AUTARC MEDIA GmbH, CH
Tracks 5 & 9 are owned by Dominion Entertainment, Inc.

CD 02
ON THE ROAD AGAIN

01 **Canned Heat – On The Road Again*** 03:21
(Floyd V. Jones/Alan Wilson) · EMI Unart Catalog Inc./EMI U Catalog Inc./EMI Partnership MV GmbH & Co. KG

02 **Hank Davison Band – Motorcycle Mama** 04:55
(Bootsman) · (P) 2004 Turicaphon AG/Switzerland · With courtesy of da Music/Deutsche Austrophon GmbH & Co. KG

03 **Molly Hatchet – Come Hell Or High Water** 03:40
(Bobby Ingram/P. McCormack) · Melody Crafter Music, Inc./MCA Publishing/Ed. SPV · (P) 1996 SPV Recordings, a division of SPV GmbH · ISRC: DE-A45-96-01630 · With courtesy of SPV GmbH · Taken from the album "Devil's canyon"

04 **Eric Burdon – Highway 62** 05:30
(Eric Burdon/Tony Braunagel/Johnny Lee Schell) · Eric Burdon Music/Hear No EvilMusic, Toe Knee Music/ Bob-A-Lew Songs, Hot Sheet Music · (P) 2004 SPV Recordings, a division of SPV GmbH · With courtesy of SPV GmbH · Taken from the album "My Secret Life"

05 **The Marshall Tucker Band – How Can I Slow Down** 03:24
(Toy T. Caldwell Jr.) · Spirit One Music/Marshall Tucker Publ. Co./Wintrup MV Walter Holzbaur

06 **Hank Davison Band – Come On And Say Yeah** 03:45
(Winiarski/Davison) · Edition Turicaphon AG · (P) 2004 Turicaphon AG/Switzerland · With courtesy of da Music/Deutsche Austrophon GmbH & Co. KG

07 **Johnny Nicholas & The Texas All Stars – Boogie Back To Texas** 03:04
(Ray Benson Seifert) · Bob Lew Songs/Paw-Paw-Music/Bob-A-Lew-Songs/Global MV GmbH & Co. KG

08 **The Marshall Tucker Band – You Don't Live Forever** 03:58
(Thomas M.Caldwell) · Spirit One Music/Marshall Tucker Publ. Co./Wintrup MV Walter Holzbaur

09 **Samson – Reach For The Sky** 04:38
(Paul Samson/Christopher Robin Aylmer/Nicky Moore/Peter Jupp) · Rondor Music London Ltd./Rondor-Music Inc./Rondor MV GmbH

10 **Lynyrd Skynyrd – Pick 'em Up** 04:20
(Van Zandt, Medlocke, Thomasson, Rossington) · Copyright Control/Pand P Songs. Ltd. · (P) 2003 Sanctuary Records Group Ltd. · ISRC: GB-AJE-03-00201 · Licensed courtesy of Sanctuary Records Group Ltd

11 **Saxon – Motorcycle Man*** 04:29
(Peter Rodney Byford/Stephen Dawson/Peter Francis Michael Gill/Graham Oliver/Paul Anthony Quinn) · Axis Music Ltd./Carlin Music Corp./Greenhorn MV GmbH & Co. KG

12 **The Marshall Tucker Band – Long Hard Ride** 03:55
(Toy T. Caldwel Jr.) · Spirit One Music/Marshall Tucker Publ. Co./Wintrup MV Walter Holzbaur

13 **Steve Miller Band – Going To Mexico (live)** 04:03
(Jack Blades) · Ranch Rock Music/BMI

* New recordings by original artists
Tracks 1, 7, 9, 11 & 13 are licensed from AUTARC MEDIA GmbH, CH
Tracks 5, 8 & 12 are owned by Dominion Entertainment, Inc.

CD 03
KICKSTART TO FREEDOM

01 **Molly Hatchet – Kickstart To Freedom** 04:35
(Bobby Ingram/P. McCormack) · Melody Crafter Music, Inc./BMI Affiliate · (P) 2002 SPV Recordings, a division of SPV GmbH · ISRC: DE-A45-00-04190 · With courtesy of SPV GmbH · Taken from the album "Kingdom of XII"

02 **Canned Heat – Big Road Blues*** 02:01
(Frank Cook/Bob Hite/Samuel Lawrence Taylor/ Henry C.Vestine/Alan Wilson) · Re Heated Music/Bug Music Inc./Bug Music Musikverlagsgesellschaft mbH

03 **Waylon Jennings & Jessi Colter – Deep In The West** 03:37
(Gren Lee Russell) · Black Coffee Music Inc./Bug Music Inc./Evening-Pigeon-Music/Bug Music · Musikverlagsgesellschaft mbH

04 **Leilah Safka & Rick Darnell – Back On The Street Again** 03:15
(Herbert Hildebrandt-Winhauer) · Edition Winhauer/Aloha Publishing

05 **The Marshall Tucker Band – Take The Highway** 06:16
(Toy T. Caldwell, Jr.) · Spirit One Music/Marshall Tucker Publ. Co./Wintrup MV Walter Holzbaur

06 **Carry & Ron – Roulette Wheel** 03:04
(Todd David Cerney/Kent Marshall Robbins) · Irving Music Inc./Rondor-Music Inc./Rondor MV GmbH/ Kronen-MV Michael Holm KG

07 **Leon Russell – I'm Moving On** 03:47
(Hank Snow/Jethro Burns/Henry Doyle Haynes) · Hill And Range Songs Inc./MV Intersong GmbH & Co. KG

08 **The Marshall Tucker Band – Fire On The Mountain** 03:57
(George Freeman McCorkle) · Spirit One Music/Marshall Tucker Publ. Co./Wintrup MV Walter Holzbaur

09 **Shania Twain – Wild And Wicked** 03:10
(Paul Sabu/Shania Twain) · Jungle Boy Music/Loon Echo Inc./Universal Songs Of Polygram Inc./Zomba Songs/Universal Music Publ. Int. Ltd./Aloha Publishing/Musik Edition Discoton GmbH/Universal Music Publ.GmbH

10 **The New Eagles – Hotel California** 06:20
(Don Felder/Glenn Lewis Frey/Don Henley) · Warner Bros.Music/Neue Welt MV GmbH & Co. KG

11 **Saxon – Denim And Leather*** 05:23
(Biff Byford/Stephen Dawson/Peter Francis Michael Gill/Graham Oliver/Paul Anthony Quinn) · Saxongs/Carlin Music Corp./Greenhorn MV GmbH & Co. KG

12 **Creedence Clearwater Revided – Up Around The Bend** 02:52
(John C. Fogerty) · Jondora-Music/Prestige Music Ltd. (PRS-MCPS)

13 **Saxon – Stallions Of The Highway (live)*** 03:18
(Peter Rodney Byford/Stephen Dawson/Peter Francis Michael Gill/Graham Oliver/Paul Anthony Quinn) · Saxongs/Carlin Music Corp./Greenhorn MV GmbH & Co. KG

*New recordings by original artist
Tracks 2, 3, 4, 6, 7 & 9-13 are licensed from AUTARC MEDIA GmbH, CH
Tracks 5 & 8 are owned by Dominion Entertainment, Inc.

CD 04
LET IT RIDE

01 **Bachmann-Turner Overdrive – Let It Ride (live)** 03:35
(Randy Bachman/Charles Fred Turner) · Randy Bachman Music/Sony-ATV Songs LLC/Sony-ATV Music Publ. Germany GmbH

02 **Girlschool – Race With The Devil (live)** 03:07
(Tex Davis/Gene Vincent) · Central Songs/Bosworth And Co. Ltd./ Campbell, Connelly And Co. Ltd. (PRS-MCPS)

03 **Creedence Clearwater Revided – Proud Mary** 03:35
(John C. Fogerty) · Jondora-Music/Burlington Music Co. Ltd./MV Intersong GmbH & Co. KG

04 **Saxon – Freeway Mad (live)*** 03:23
(Peter Rodney Byford/Stephen Dawson/Peter Francis Michael Gill/Graham Oliver/Paul Anthony Quinn) · Axis Music Corp./Carlin Music Corp./Greenhorn MV GmbH & Co. KG

05 **Allman Brothers Band – Statesboro Blues** 04:34
(Blind Willy McTell) · Peermusic (UK) Ltd. · (P) 1970 Castle Copyrights Licensed courtesy of Sanctuary Music Group, Ltd. · ISRC: GBAJE0503080

06 **Ian Gillan – Smoke On The Water (live)** 07:59
(Richard Blackmore/Ian Gillan/Roger David Glover/Jon Lord/Ian Anderson Paice) · B. Feldman And Co. Ltd./EMI Music Publ. Ltd./EMI Music Publ. Germany GmbH & Co. KG

07 **The Marshall Tucker Band – Never Trust A Stranger** 05:29
(Thomas M.Caldwell) · Spirit One Music/Marshall Tucker Publ. Co./Wintrup MV Walter Holzbaur

08 **Carry & Ron – Juke Box Saturday Night** 02:13
(Paul James Mac Grane/Al Stillman) · Chappell-Co., Inc./Chappell & Co. GmbH & Co. KG

09 **Creedence Clearwater Revided – Hey Tonight** 02:45
(John C. Fogerty) · Jondora-Music/Prestige Music Ltd. (PRS-MCPS)

10 **Lynyrd Skynyrd – Sweet Mama** 03:59
(Van Zandt, Medlocke, Rossington) · Bug Music Ltd. · (P) 2003 Sanctuary Records Group Ltd. · ISRC: GB-AJE-03-00205

11 **Girlschool – Hit 'n' Run** 03:22
(Bernadette Jean Johnson/Kim McAuliffe) · CMI America/MCS Music America Inc. (ASCAP)

12 **The Marshall Tucker Band – Take The Highway (live)** 07:27
(Toy T. Caldwell, Jr.) · Spirit One Music/Marshall Tucker Publ. Co./Wintrup MV Walter Holzbaur

13 **Rose Tattoo – The Devil Does It Well** 05:32
(Wells/de Soto) · Albert Productions · (P) 2002 Steamhammer, a division of SPV GmbH · ISRC: DE-A45-02-02430 · With courtesy of SPV GmbH · Taken from the album "Pain"

*New recordings by original artist
Tracks 1, 2, 3, 4, 6, 8, 9 & 11 are licensed from AUTARC MEDIA GmbH, CH
Tracks 7 & 12 are owned by Dominion Entertainment, Inc.

This compilation (P) 2006 edel CLASSICS GmbH

INDEX OF PHOTOGRAPHY

Sturgis Rally / South Dakota
© Michael Lichter Photography, LLC

Sturgis Rally / South Dakota
© Michael Lichter Photography, LLC

Sturgis Rally / South Dakota
© Michael Lichter Photography, LLC

Flower Power Festival – Oelde / Germany
Biker Mania – Saalbach-Hinterglemm / Germany
© Michael Stein / MI

Laconia Rally / New Hampshire
© Michael Lichter Photography, LLC
Biker Mania – Saalbach-Hinterglemm / Austria
© Michael Stein / MI

Laconia Rally / New Hampshire
© Michael Lichter Photography, LLC

Biker Mania – Saalbach-Hinterglemm / Austria
European Bike Week – Faak / Austria
© Michael Stein / MI

Sturgis Rally / South Dakota © Michael Lichter Photography, LLC
Hamburg Harley Days / Germany © Michael Stein / MI
Harley-Davidson 100th anniversary – Milwaukee / Wisconsin
© Michael Lichter Photography, LLC

Wolfgang Fierek, Mountain Mania – Saalbach-Hinterglemm / Austria
© Michael Stein / MI

Hamburg Harley Days / Germany
H-D Folks Festival – Erbach-Ringingen / Germany
© Michael Stein / MI

Edersee Meeting – Hemfurth / Germany
Green Hills Run – Wolfegg / Germany
© Michael Stein / MI

Sturgis Rally / South Dakota
© Michael Lichter Photography, LLC

Daytona Bike Week / Florida
© Michael Lichter Photography, LLC
Ibiza Bike Week / Spain
© Michael Stein / MI

Daytona Bike Week / Florida
Sturgis Rally / South Dakota
© Michael Lichter Photography, LLC

Laconia / New Hampshire
© Michael Lichter Photography, LLC
8th European H.O.G Rally – Sheltenham / Great Britain © Michael Stein / MI
Harley-Davidson 100th anniversary – Milwaukee / Wisconsin
© Michael Lichter Photography, LLC

Daytona Bike Week / Florida
© Michael Stein / MI
Harley-Davidson 100th anniversary – Milwaukee / Wisconsin
© Michael Lichter Photography, LLC

Daytona Bike Week / Florida
Harley-Davidson 100th anniversary – Milwaukee / Wisconsin
© Michael Lichter Photography, LLC

Biker Mania – Saalbach-Hinterglemm / Austria
Harley-Davidson Meeting – Fehmarn / Germany
© Michael Stein / MI

„Just Married" Limited Edition, Sturgis Rally / South Dakota
© Michael Lichter Photography, LLC
Mountain Mania – Saalbach-Hinterglemm / Austria
© Michael Stein / MI

National Motorcycle Museum – Anamosa / Iowa
© Michael Lichter Photography, LLC

▌ Harley-Davidson Meeting – Fehmarn / Germany
▌ "Ruhrpott Friends" Event – Herten / Germany
© Michael Stein / MI

▌ Sturgis Rally / South Dakota
▌ Biker Mania – Saalbach-Hinterglemm / Austria
© Michael Stein / MI

▌ Peter Fonda, Laconia Rally / New Hampshire
▌ Sturgis Rally / South Dakota
▌ Daytona Bike Week / Florida
▌ Myrtle Beach / South Carolina
© Michael Lichter Photography, LLC

▌ Sturgis Rally / South Dakota
© Michael Lichter Photography, LLC

▌ European Bike Week – Faak / Austria
© Michael Stein / MI

▌ Sturgis Rally / South Dakota
© Michael Lichter Photography, LLC

▌ Sturgis Rally / South Dakota
▌ Daytona Bike Week / Florida
© Michael Lichter Photography, LLC

▌ Biktoberfest – Daytona Beach / Florida
▌ Daytona Bike Week / Florida
© Michael Lichter Photography, LLC

▌ Billy Lane / Choppers Inc., Daytona Bike Week / Florida
▌ Jesse James / West Coast Choppers. © Michael Lichter Photography, LLC
▌ Marcus Walz / Hardcore Cycles, Schadow Arkaden Charity Run – Düsseldorf / Germany © Michael Stein / MI
▌ Paul Cox, Myrtle Beach Bike Week / South Carolina
▌ "Orange County Choppers", American Chopper on Discovery Channel
© Michael Lichter Photography, LLC

▌ Sturgis Rally / South Dakota
© Michael Lichter Photography, LLC

▌ Rick Fairless, Biktoberfest – Daytona / Florida
▌ Biktoberfest – Daytona Beach / Florida
© Michael Lichter Photography, LLC

▌ Paul Teutul sr. – Sturgis Rally / South Dakota
▌ Paul Teutul sr.& jr. – Daytona Bike Week / Florida
© Michael Lichter Photography, LLC

▌ Billy Lane / Choppers Inc., Myrtle Beach Bike Week / South Carolina
© Michael Stein / MI

▌ Frank Sander / Independent Choppers – Hamburg Harley Days / Germany
▌ Sturgis Rally / South Dakota
© Michael Lichter Photography, LLC

▌ Paul Yaffe / PYO – Sturgis Rally / South Dakota
© Michael Lichter Photography, LLC

▌ Daytona Bike Week / South Dakota
▌ Sturgis Rally / South Dakota © Michael Lichter Photography, LLC
▌ European Bike Week – Faak / Austria © Michael Stein / MI
▌ Laconia Rally / New Hampshire
▌ Myrtle Beach / South Carolina © Michael Lichter Photography, LLC

▌ W&W Crew, European Bike Week – Faak / Austria
▌ Magic Bike Rally – Rüdesheim / Germany
© Michael Stein / MI

▌ Love Ride – Glendale / California
▌ Daytona Bike Week / Florida
© Michael Lichter Photography, LLC

▌ Sturgis Rally / South Dakota
© Michael Lichter Photography, LLC

▌ Biktoberfest – Daytona Beach / Florida
▌ Run to the Wall – Washington D.C.
© Michael Lichter Photography, LLC

INDEX OF PHOTOGRAPHY

- Laconia Rally / New Hampshire
© Michael Lichter Photography, LLC

- European Bike Week – Faak / Austria
© Michael Stein / MI

- Colour restricted area – New Zealand
- Sturgis Rally / South Dakota
- Daytona Bike Week / Florida
© Michael Lichter Photography, LLC

- Sturgis Rally / South Dakota
© Michael Lichter Photography, LLC

- "Masked Biker" / Limited Edition
© Michael Lichter Photography, LLC

- Daytona Bike Week / Florida
© Michael Lichter Photography, LLC

- H-D Motorcycle Jamboree – Biesenthal / Germany © Michael Stein / MI
- Sturgis Rally / South Dakota
- Daytona Bike Week / Florida
© Michael Lichter Photography, LLC

- Harley-Davidson 100th anniversary – Milwaukee / Wisconsin
© Michael Lichter Photography, LLC

- Daytona Bike Week / Florida (top left)
- Sturgis Rally / South Dakota
© Michael Lichter Photography, LLC

- Sturgis Rally / South Dakota
© Michael Lichter Photography, LLC

- Sturgis Rally / South Dakota
- Harley-Davidson 100th anniversary – Milwaukee / Wisconsin
© Michael Lichter Photography, LLC

- Sturgis Rally / South Dakota
- Daytona Bike Week / Florida
© Michael Lichter Photography, LLC

- Daytona Bike Week / Florida
- Ibiza Bike Week / Spain
© Michael Stein / MI

- Sturgis Rally / South Dakota
© Michael Lichter Photography, LLC

- Paul Cox & Indian Larry (†), Daytona Bike Week / Florida
- Sturgis Rally / South Dakota
- Biktoberfest / Florida
© Michael Lichter Photography, LLC

- "Bad Barbies" / Limited Edition
- Sturgis Rally / South Dakota
© Michael Lichter Photography, LLC

- Sturgis Rally / South Dakota
© Michael Lichter Photography, LLC

- Jean Claude Passetempes / School Bar Atelier – Daytona Bike Week / Florida
© Michael Lichter Photography, LLC

- Paul Cox, Sturgis Rally / South Dakota
© Michael Lichter Photography, LLC
- Indian Larry (†), Laconia Rally / New Hampshire
© Michael Stein / MI

- Paul Cox, Sturgis Rally / South Dakota
© Michael Lichter Photography, LLC